wrangling the doubt monster:
Fighting Fears, Finding Inspiration

Amy L. Bernstein

Wrangling the Doubt Monster

Copyright 2025: Amy L. Bernstein. All rights reserved

No part of this book may be reproduced in any form or by electronic means, including information storage and retrieval systems, without written permission from the publisher, except by a reviewer, who may quote passages in a review.

Cover Design: Christine VanBree
Interior Design: Tracy Copes
Illustrations: Mary Grace Corpus
Author Photo: Ceylon Mitchell

978-1-61088-638-3 (HC)
978-1-61088-639-0 (PB)
978-1-61088-640-6 (ebook)
978-1-61088-641-3 (PDF ebook)

Published by Bancroft Press
"Books that Enlighten"
(818) 275-3061
4527 Glenwood Avenue
La Crescenta, CA 91214

www.bancroftpress.com

preface

What do we have here?

 A doubter's manifesto.

 An article of affirmation.

 An artist who says: *I see you.*

Read these pages in order or at random. Read them while creating a story, a dance, a sculpture, a poem, a painting, a weaving, a song...

The hope is you

 see yourself,

 realize you are not alone,

 learn that doubt is not your assassin.

A bit of truth, a bit of courage, floats across these pages.

Some repetition too—because you need to hear this more than once.

And a wisp of contradiction because...that's life.

I need this as much as you.

introduction, part 1: swimming clear

In 1908, a French mathematician you probably never heard of, Henri Poincaré[1], got stuck on a complex math problem. In frustration, he left the problem alone and stopped thinking about it.

Some time later (weeks or months; it's unclear), he had a sudden breakthrough, linking two concepts that were "wrongly believed to be strangers to one another," he explained. He credited his unconscious mind with working the problem (unbeknownst to him), and then bringing the discovery forward to his conscious attention.

Poincaré may have experienced a phenomenon for which there was no label at the time: *cognitive disinhibition.*[2] Simply put, a creative thinker (aka, an artist) is in a state of cognitive disinhibition when they allow all manner of unrelated and disparate ideas to come together to make or contribute to something new—whether a dance, a painting, a story, a mathematical proof, etc.

Whether this desirable state—where the mind is wide open to receive and consider all possibilities in the universe—occurs only at an unconscious level, I can't say (and I'm not sure anyone can). But according to psychologists, people who demonstrate high levels of cognitive disinhibition report high levels of real-world creative accomplishments.

Put simply: It pays for artists to have an open mind—a really, really open mind. Open to the absurd, the taboo, the old, and the new.

It follows, then, that the more "stuff" gets in the way of opening your mind wide and holding it open as much as possible…anything that prevents you from jumping into the river of cognitive disinhibition for a refreshing swim…is not doing you any favors.

In real life, a lot of stuff gets in the way: family, work, accidents, illness, depression, travel, death.

And let's not forget one more, the "stuff" artists specialize in: doubt.

Let's manifest a world in which doubt loosens its grip enough for us to swim out in the open, in the clear, in the deep end of our imaginations.

"**Nothing** is more poisonous to the nervous system than a *disregarded* or *checked* **creative impulse.**"

Carl Jung[3]

introduction, part 2: it's in the air

Are your doubts as an artist affected—possibly even determined—by the culture around you?

I'm not referring to your dad, who thinks you need to find a "real" job and stop futzing around with art.

I'm referring to the dominant culture and society in the country where you live (or have spent the most time). There could be a connection, even if it's tangential, between your cultural environment and the severity or prevalence of your doubts about practicing your artform.

Geert Hofstede, a Dutch social psychologist, came up with the Uncertainty Avoidance Index (UAI)[4]—a way to measure a culture's tolerance for uncertainty and ambiguity—a few decades ago.

In a nutshell:

- Countries that seek to avoid uncertainty tend to impose strict laws and rules that inhibit or discourage certain behaviors, such as risk-taking.

- Countries with a high tolerance for uncertainty, on the other hand, are more tolerant of divergent opinions and impose fewer rules on their citizens. They tend to embrace innovation and risk-taking and recognize the accomplishments of individuals.

As a tool, the UAI is imperfect and has been criticized for its theory and methodology. Nevertheless, there's a grain of truth here. A country like Russia, which scores high as an uncertainty avoider, has been known to persecute (and prosecute) artists. Whereas the U.S., UK, Jamaica, and Singapore (among others), where cultural tolerance for uncertainty is relatively high compared with many other nations, tend to let artists, and the arts, take root with and without official support.

My point is: As an artist acutely doubting your abilities, consider culture's impact on your state of mind.

In other words: Your persistent doubts may be due, in part, to external factors and influences that you were not aware of—until now.

The upshot: You are not crazy.

> "I am even more certain that to create dangerously is also to create fearlessly, **boldly embracing the public and private terrors that would silence us,** then bravely moving forward even when it feels as though we are chasing or being chased by ghosts."
>
> Edwidge Danticat[5]

introduction, part 3: the throw-down

A young Sylvia Plath wrote in her journal that "the worst enemy to creativity is self-doubt."[6]

That sounds true, but I don't think it *is* true.

Her assertion implies that only by banishing doubt can you effectively be creative—to practice your art. There are moments, to be sure, when an artist in the flow of creativity (cognitive disinhibition) does not feel doubt blocking the way.

But realistically, doubt is a near-constant companion of anyone making art in any form.

Doubt is fuel as well as foe.

Let us therefore not engage in fruitless attempts to banish doubt, or even conquer it.

Let us seek productive co-existence with this emotional shadow that hovers nearby, just out of sight, like a ghost.

Let us befriend the ghost.

> **"Choosing the future** involves striking out in a **new** direction, whereas choosing the past involves shrinking back into *what is familiar and already known.*"
>
> Salvatore R. Maddi[7]

doubt [dout]

Derived from the Middle English *douten* and before that, from the Latin *dubitāre,* linguistically rooted in duo "two" (-dwo), with a sense of

"two minds, undecided between two things."

The word's meaning is a consistent capsule of anguish and second-guessing through the ages:

- to dread
- to fear
- to feel unsure
- to be afraid or worried
- to hesitate
- to be confused
- to waver while coming to an opinion

About those

> **"two minds, undecided between two things."**

What two minds?

What two things?

Like Whitman, you contain multitudes.

Like the ancient Chinese legacy of yin and yang, you are a duality:

>light and dark,

>positive and negative,

>receptive and resistant.

You are doubt and certainty—never all one or the other, but both, together, forever inseparable.

And therein lies your strength to go on.

> "If you have no doubt,
> you are not sane."
>
> Tage Danielsson

René Descartes said, "I think, therefore I am."

Equally true: "I doubt, therefore I am."

Doubt is to life as water is to life.

We do not live without either.

We do not live without a persistent undercurrent of questions, both tiny and tremendous. Anyone who claims never to doubt—or to "suffer" from a state of doubt—is lying, either to themselves or to everyone.

Doubt is baked into the human condition and transcends culture, epoch, and geography.

People all over the world, in every time period, speak of doubt and the crises of faith it engenders.

Doubt is with us/within us/us.

"Practice only envisioning yourself at the finish line and be **unrelenting** and **fervent** in **racing towards that finish line**. Undue preoccupation and fixation with the hows, whens, and what-ifs will not only derail and further distance you from your destination, but will also feed your mind with those fatal seeds of doubt that make failure inevitable."

Ogor Winnie Okoye[8]

"Rembrandt clutched his palette convulsively,
advanced the brush to the canvas,
then threw it down.

Inarticulate words betrayed the artist's doubts;
his execution had not reached
to the full height of his standard."

MM Erckmann-Chatrian, 1881[9]

Every single act of creating is also an act of doubting.

You cannot "make" without wondering.

You cannot wonder without questioning.

You cannot question—deeply—without exposing yourself to the unknown.

Becoming exposed leads to feeling vulnerable.

Feeling vulnerable leaves you open to uncertainty.

Uncertainty is a close cousin of doubt: a state where truth and clarity shimmer like ghosts.

So much you do not know, cannot pin down. Cannot point to and say, *Yes! That!*

When you create, you will doubt: Accepting that is your gift to yourself.

"The more you practice **"waving"** at your self-doubt in recognition, the more familiar that self-doubt becomes. This familiarization functions like a declawing, in which even your most unpleasant feelings gradually become less of a threat to your creative work."

Dale Trumbore[10]

Doubt is a story you tell yourself, often in secret.

The secret telling, all that yelling deep inside, gives the story power.

Power *over* you. *In* you.

Your doubt story, each chapter voiced unbidden, crowds out other stories that are far more important.

For instance:

> The story about how your craft brings you joy.
>
> The story about the unexpected discoveries you make—all that serendipity.
>
> The story about your wishes and visions.
>
> The story about sharing your art with the world.
>
> The story of an ending—a happy ending.

Take back your story. Tell doubt to be seen but not heard. Let the voices in your head tell new stories about your life as an artist.

Assert your power over doubt: It is your right.

Doubt is a story you tell yourself, about yourself. Almost like tattling on yourself.

Once upon a time…

> I didn't think I could.
> I didn't think I should.
> I wasn't good enough to try.
> I didn't know enough to "do."
> I was lesser than…

You are full of stories, and your doubt story is only one among many.

Turn to a clean page and begin again.

Once upon a time…

> I leapt out into air and lived.
> I found the treasure I sought.
> I made something from nothing.
> I faced the world.
> I told everyone that I mattered.

> **"Doubters** have been remarkably productive, for the obvious reason that they have a tendency toward **investigation** and are often drawn to invest their own days with meaning."
>
> Jennifer Michael Hecht[11]

Body weight, eye color, flat arches, left-handedness, a penicillin allergy: none of these things define a person.

They are bits and pieces of someone—but not anything like the whole of someone.

You could list attributes like these, and I still would not know who you are.

You could list all your doubts about making art—the fears, hesitations, risk-aversion, do-overs, indecision, and so forth—and I still would not know who you are as an artist.

That's because your doubts are bits and pieces of you—but they do not define your artistry or your capacity to make art.

Don't let doubts fill in the blanks about who you are as an art-maker.

You are so much more than the sum of your parts—and so much more than your doubts.

Like the fog creeping in on little cats' feet, doubt has insidious ways of announcing itself:

- Repetitive thoughts
- Waking nightmares
- Panic attacks
- Paralyzing inaction
- Depression

To which we respond, *Yes, and...* Halting in our tracks affords opportunities to:

- Reflect
- Rework
- Reimagine
- Restart
- Recommit

You see? Duality. Multitudes. Yin and yang. You are all-encompassing. Doubt is but a fragment of your totality.

How can we heal from the doubts that rub us as raw as an open wound?

What salve can we apply to ease the pain?

Oh, but it's all in our heads! Yes, and our heads are hot and crowded, and far too noisy—when they're not eerily quiet.

Hard truth:

There is no little blue pill for the artist's doubts. No "take two and call me in the morning" prescription.

Doubt is an existential, chronic condition for which there is no permanent cure. (Remission is possible—but recurrence is common.)

So, then, the remedy is productive co-existence:

You may say,

> "I'm hurting. I'm lost. I'm confused."

But you will also say,

> "My doubts are real, but my art is also real."
>
> "When doubts flare, I work to the best of my ability that day."
>
> "Doubt may slow my progress—but will not stop me from inching forward."

You are the only cure that exists.

> "You can't **SIT AROUND** AND WAIT FOR SOMEBODY TO SAY WHO YOU ARE. You need to **WRITE IT** & *paint it* and do it."

Faith Ringgold

We speak of "seeds" of doubt that are sown. Where? By whom?

Has an alien implanted these seeds while you slept, waiting for its unspeakably evil offspring to burst forth?

Has your subconscious betrayed your trust, sowing seeds of doubt without your permission?

Or are these seeds an extension of your nature, planted in your native soil, where they flourish during the evolution of your art?

In which case: the seeds of doubt are organic to you—your inimitable brand of questioning.

Do not fear the seeds of doubt, for they are but the tender shoots of your resolve.

A working definition of doubt beyond the dictionary:

- Your inability to see the future.
- An acknowledgment that you are not infallible.
- A trigger for a gut-check.

In this context, doubt is incredibly normal. A normal state, like hunger or fatigue.

A human state.

The more we normalize doubt—treat it as a common, ordinary state of awareness—the less we're inclined to fear it.

Doubt is neither absence nor failure. Neither blockage nor weakness.

It is a series of clouds crossing the sun: This too shall pass.

You can live with doubt because you must—and because it does not own you.

Elaine Welteroth[12]

So much we already know about ourselves, but knowing isn't the same as changing—or even coping.

> We know that doubt is fear, but we choose to remain afraid.
>
> We know that doubt is shelter, but we refuse to come out from hiding.
>
> We know that doubt is a placeholder, but we let "fake" take the place of "real."

What else do we know?

As creators, we are the authors of our own stories.
The beginning, middle, and end are up to us.

Dwelling in perpetual doubt is not preordained.

> "As we gain strength,
> so will some of the attacks of self-doubt.
> This is normal, and we can deal with these
> stronger attacks when we see them as
> symptoms of recovery."
>
> Julia Cameron[14]

Doubt begets strength.

Doubt is a single muscle and you have scores of other muscles to flex against it.

Whenever doubt shows off with endless pull-ups, respond with a spectacular triple-flip—heels flying over head in a gravity-defying feat.

Doubt is but one voice, and you have many other voices at your command to shout it down.

Sing out in the shower, overtaking doubt's toneless repetition.

Doubt begets strength because you are stronger than your doubt—in body, mind, and soul.

Doubt is a measure of the distance between who you wish to be as an artist and who you believe yourself to actually be.

Or so you assume…

For that distance is an illusion and, by any measure, you are exactly who you need to be.

Your art is always "becoming" because that's what art is and does.

As an artist, you are constantly evolving because that's what artists do.

Doubt is speculation, not measurement.

You are a speculator and a seeker—and so what if doubt accompanies you in those roles?

> "Within each thing you're creating,
>
> no matter how you feel like you're failing
>
> within that particular exercise
>
> of that particular framework
>
> of what you're working on...
>
> there's something in there
>
> **that's opening something up in you.**"

Carlos Murillo[15]

Doubt is noisy, but fortunately we are capable of selective hearing.

The idea is not to tune *out*, but rather to tune *up*. (Another way of flexing muscles.)

You hear doubt's music loud and clear. You hear its earsplitting notes:

> *no...*
>
> *don't...*
>
> *stop...*
>
> *you can't...*
>
> *you'll never...*
>
> *don't embarrass yourself...*

Your task: adjust the volume.

Turn down to a whisper all of doubt's dissonance.

Turn up to full volume all the other lovely, affirming melodies that should become your earworms:

> *yes you can...*
>
> *invest in your risk...*
>
> *take the chance...*
>
> *plunge in...*
>
> *keep going...*
>
> *make the art...*
>
> *realize your vision...*

The only person with a hand on the "dial" is you. So use it.

Doubt is like desire, arising from your depths, unexpected, often unbidden.

And like desire, doubt claims a time and place.

But not all of the time, and not in every place.

Like desire, doubt may arise urgently, but its intensity is fleeting; the urge itself will subside.

You may yield to desire, as you do to doubt, whether willingly or only after losing a battle with resistance.

But remember the potency of your agency:

> You decide whether to say yes or no.
> You dictate the duration.
> You assign meaning to the assignation.

You do not lose *you* in the throes of desire and doubt.

> **"HERE'S TO US BEING AFRAID AND DOING IT ANYWAY"**

Gabrielle Union[13]

Doubt is a Tower of Babel, speaking many languages in your mind's echo chamber.

Luckily, you are your own universal translator.

When doubt says "stop," you should hear "keep going."

When doubt says "you are falling short," you should hear "I am everything I need."

When doubt says "you are overreaching," you should hear "I am growing by leaps and bounds."

Leave your universal translator on at all times, and crank up the volume.

> *"I don't want to be perceived as having been waiting to be allowed to speak."*
>
> Bebe Miller[22]

Doubt is a classic Trickster—a cunning or deceptive character.

Doubt is not either/or, but both:

> *Cunning* because it always finds a way to cling and clang and make a racket.
>
> *Deceptive* because you initially believe everything it tells you, about you.

How to deal with a Trickster:

1. Deny them god-like status.
2. Regard their antics with disdain.
3. Ignore all their pleas for attention.
4. Strip away their masks and disguises, revealing them as the attention-seeking infants they are.
5. Weave a spell of your own making to shut them up.

"The responsibility of the artist is to make work that's **real** and that's **reflective** of something that's **true**. You have to be *true to your own vision* of the **voice** you're trying to find."

Andrew Okpeaha MacLean[16]

Doubt is a country you visit often, but you will never live there because it is not congenial to your art.

It is too noisy or too quiet, too congested or too vacant, too dirty or too pristine, too temperate or too frigid, too hilly or too flat.

Nevertheless, over time, you have formed *la nostalgie de la boue* for this land where you perch but never quite settle.

Enjoy your visits, but don't rush back. The Country of Doubt is not going anywhere. Don't linger out of a misbegotten sense of obligation.

Your true obligation is to the interior landscapes in the secret country of your own making.

That is where your best artist-self lives most comfortably.

> "to **dream** is to starve doubt, **feed hope.**"

Justina Chen[17]

Doubt is a question holding a knife.

A question, by itself, can be innocent or sinister. But hand that question a knife, and all at once you are in danger.

What sort of danger?

Danger that exposes your deepest vulnerabilities, plumbs your weaknesses, finds flaws in your logic, pokes holes in your systems… tears you down…

Here's what no one tells you about the danger of doubt:

Your innermost core remains intact in the face of danger-doubt attacks.

Your talent remains untouched, uncontaminated.

Your power as an originator—a maker of the "new"—is unassailed.

That knife? It is rubber. You are unyielding steel.

You need only recognize that you are strong enough to hold the knife at bay.

Give yourself permission to believe this—and remember it whenever doubt wields a knife in your face.

Imagine doubt as a trebuchet—

a long-armed catapult that fires heavy balls of destruction into your backyard.

You cannot predict the assault or the damage it will cause—but you wait, crouching, for the next onslaught.

The waiting paralyzes you, atrophies all your senses except for anxious anticipation.

You think of nothing but the attack that surely is about to come… that is already coming…

This is how you wither.

And this is no way to live. So carry on despite the canon balls lobbed in your direction…

Or maybe, because of them.

Practice dodging until you are as adept as a ballet dancer on a battlefield, making beauty amid crisis.

Imagine doubt as a natural law which, like gravity, reassuringly behaves the same way with every encounter.

Just as gravity catches every footfall, doubt encapsulates your worries and fears and bouts of self-loathing as surely and predictably as gravity.

You may rely on doubt to be there for you, to dog your days and nights, as inescapably as gravity.

And so: What do you do about a natural law that co-exists with life itself?

You can marvel at doubt's constancy, accept its repetitive nature, and use it to fuel your art like a hot air balloon that appears to break all the rules.

"Doubt yourself and you doubt everything you see.

Judge yourself and you see judges everywhere.

But if you listen to the sound of your own voice,

you can rise above doubt and judgment.

And you can see forever."

Nancy Lopez

Imagine that words carry their own energy full of mass and essence and transformation.

What, then, is the energy of doubt?

Perhaps a forcefield or vibration, constantly felt but never seen.

Maybe the energy of doubt is inextricably linked with the energy of the artist—you.

Sometimes you are flooded by its waves, thick as jelly.

Other times, doubt's translucence passes like sand through open fingers.

Doubt's energetic weather changes but endures—and so do you.

Creating amid doubt is like picking your way across a minefield, your momentum slowed by the danger in every step.

How to cross safely?

With caution—perhaps.

Or perhaps entirely *without* caution.

You pirouette your way across dangerous ground, trusting in the all-but-neglected powers of intuition and instinct to guide you to the far side in one piece.

Caution has no place in art-making. The danger—the doubt—is always there, whether buried beneath you, pelting you from above, or stabbing you from within.

But you must cross. You must make the journey. You must create momentum—to be the body in motion that stays in motion.

You must make your art both in spite of, and because of, the danger that doubt imposes.

It is what you are called to do.

"The relationship between **commitment & doubt** is by no means an antagonistic one. Commitment is healthiest when it's not **without** doubt but **in spite of** doubt."

Rollo May[18]

Doubt may as well be an element of physics, for it is a form of friction—

> the <u>resistance</u> that one surface or <u>object</u> encounters when <u>moving</u> over another—

where

> resistance = your hesitation (doubt!)
>
> the object = your art
>
> movement = your screeching halt

You should embrace friction, for without it, everything slides to the ground, slips from your hands.

In art-making, doubt's frictive qualities can give rise to productive questions and fresh choices—to keep things bubbling.

Don't fight doubt's physicality. Work with it; make the push and pull and the rub your friend, not your enemy.

After all, we all scrape and claw our way to creation: art is friction, shaped to suit yourself.

Doubting is not failing.

Doubting is not succeeding.

Doubting is not about getting ahead or falling behind; stopping or starting.

Doubting exists in that liminal space where every aspect of art-making is a shade of effort—an embryo of creation.

Doubting may feel like rocket fuel or like doom—but imagine it is neither of those.

Hold space for doubt without imposing labels.

Reserve judgment:

>of yourself
>of your art-in-progress
>of what's in your head/hand/heart

Doubt arises during the many phases of art becoming art. Let it be. Leave it alone.

Keep working.

Doubt is not a poison killing your creative spirit.

How can it be when you are the alchemist in charge?

You choose the ingredients to make the tonic that strengthens your resolve.

You follow your own recipe of moods, needs, visions, and intentions.

You flavor this brew with essences you select:

> Flowers. Sandalwood. Leather. Turpentine. Ink. Clay. Cadmium white. Silk. The steel beneath the welder's torch.

Doubt cannot work upon you like poison if it is made by your hand—infused with love, commitment, and talent.

Some days, doubt is a dreary, ever-present companion. A bore and a drag. A scold and a nag.

Doubt's constant presence is exhausting. You feel it draining your life force. Creative energy swirls down the drain of doubt's enervating spiral.

On such days, doubt feels like a chronic disease settling into your bones and nerves.

What's the remedy?

Make a tiny bit of art:

> A word on a page. A stitch in fabric. A brushstroke of paint. A nail hammered into wood.

Then make another. And another.

Simply *make*. You need not *make sense*.

Do this, and work your way back to artistic health, doubt shrinking with each gesture.

Making is believing.

"[I]t is in the act of *acceptance* of that which is beyond us, and over which we have no mastery, that we confront our **anxiety** and relinquish our **fear**."

Paul Tillich[20]

"The wind of confusion

will always be blowing against you,

and monsters of one sort or another,

like poverty or disillusionment,

wait to ambush you around the bend.

You will have to contend with your own

doubts and limitations, as well as the loneliness

that comes with setting yourself

upon the artist's course in the first place.

To keep at it with dignity and without bitterness,

find beacons that guide you and

meanings that sustain you."

Enrique Martínez Celaya[19]

What a shape-shifter doubt is!

It has been called

> a stone,
> a thorn,
> a cloud,
> a stampede,
> an enemy,
> a killer,
> a voice,
> a seed…

Doubt may be all of these things…and none of these things.

You are the giver-of-names.

You are the maker of labels.

You call a thing what it is—for you.

And doubt?

Call it anything at all—Murgatroyd or Peppermint.

Whatever you name, you can control.

> "There is a crack,
> a crack in everything.
> That's how the light gets in."

Leonard Cohen[21]

coda: wrangling the doubt monster, for real

Sometimes, we all need more than inspiration—we need action.

Incorporating these four steps as part of your mental hygiene routine may help you develop a habit of living with doubt.

Step 1

The process begins with some basic self-owning:

I have deep doubts about my ability to do X. I might do it badly. I might fail entirely. I might be ill-equipped even to try. Doubt: I see you and feel you.

Step 2

Put doubt in perspective:

I readily acknowledge my doubts about this effort, but self-doubt is one feeling among many and not a reliable predictor of the truth. Doubting, by itself, does not pre-determine outcome.

Step 3

Make doubt an ally:

Doubt is a form of protection that focuses my attention. My doubts are not telling me "no," they're telling me where to sharpen and apply my skill, talent, intellect, etc., toward achieving my goal.

Step 4

Practice productive coexistence—the powerful "yes and…" formula:

I have doubts and I'm going to proceed anyway without compromising my ambitious aims, high standards, and grand vision.

Take these steps seriously and you may well find yourself unlocking doors you were convinced you could not pass through. You will find joy in taking creative risks you thought would do you in.

I wish you success and happiness in all your creative endeavors.

> "When we are not sure, we are alive."

Graham Greene

about the author

I write (and doubt) in Baltimore, Maryland. After a career in journalism, and government and nonprofit communications, I turned to fiction—fulfilling a lifelong promise to myself.

I'm the author of numerous plays, poems, and essays, and several published novels.

I teach courses about aspects of writing to writers around the world. 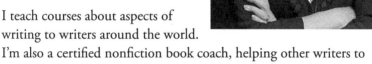 I'm also a certified nonfiction book coach, helping other writers to confront their doubts on the road to publication.

Learn more at https://amywrites.live. I'd love to hear from you—doubts and all.

a note on sources

For quotations, I sampled BIPOC (Black, Indigenous, and People of Color) and white artists, psychologists, and philosophers from a variety of countries and backgrounds. I also explored ideas on doubt, creativity, and art from different periods and perspectives.

Quotations not cited in end notes were not linked to a source publication. Those quotations were derived from Google Books and these sites:

- https://www.audible.com/blog/quotes-black-americans
- https://www.girlsthatcreate.com/quotes-from-black-women-creators/
- https://brainyquote.com
- https://searchquotes.com
- https://quotefancy.com

I also used www.goodreads.com, and was able to trace those quotations back to source books.

end notes

1 Weisberg, R. W. (2018). Expertise and structured imagination in creative thinking: Reconsideration of an old question. In K. A. Ericsson, R. R. Hoffman, & A. Kozbelt (Eds.), Cambridge Handbook of expertise and expert performance (2nd ed.). Cambridge University Press.

2 Ibid.

3 Creativity and the imagination. (2015). In J. Harris (Ed.), The quotable jung. Princeton University Press.

4 https://www.cqfluency.com/cqpedia/uncertainty-avoidance-index/

5 Danticat, E. (2011). Create Dangerously: The Immigrant Artist at Work. Vintage.

6 Plath, S. (2000). The Unabridged Journals of Sylvia Plath. Anchor.

7 Maddi, S.R. (2004). In W. E. Craighead, & C. B. Nemeroff (Eds.), The concise Corsini encyclopedia of psychology and behavioral science (3rd ed.). Wiley.

8 Okoye, O.W. (2012). Awaken and Unleash Your Victor: Uncover the Path to Your Magnificent Destiny. iUniverse.

9 Erckmann-Chatrian. (1881). In Temple Bar, a London magazine for town and country readers. Abraham's Sacrifice. Publisher unknown.

10 Drumbore, D. (2019). Staying Composed: Overcoming Anxiety and Self-Doubt Within a Creative Life. Independently published.

11 Hecht, J.M. (2004). Doubt: A History. HarperOne.

12 Welteroth, E. (2020). More Than Enough: Claiming Space for Who You Are. Penguin.

13 Union, G. (2019). We're Going to Need More Wine. Dey Street.

14 Cameron, J. (2016). The Artist's Way, 30th Anniversary Edition. TarcherPerigree.

15 National Endowment for the Arts. (2020). The Wisdom of Artists: A Collection of Inspirational Quotes by BIPOC Creatives. Gathered from NEA blogs, podcasts, and other sources. https://www.arts.gov/stories/blog/2021/wisdom-artists-collection-quotes-bipoc-artists

16 Ibid.

17 Chen, J. (2009). North of Beautiful. Little, Brown.

18 May, R. (1994). The Courage to Create. W.W. Norton.

19 Celaya, E.M. (2020). Collected Writings and Interviews: 2010-2017. University of Nebraska Press.

20 Tillich, P. (1952). The Courage to Be. Yale University Press.

21 Cohen, L. (1992). Lyrics from the song "Anthem" on the album "The Future." Columbia Records.

22 National Endowment for the Arts. The Wisdom of Artists. Op. cit.